The Poetry of Solitude

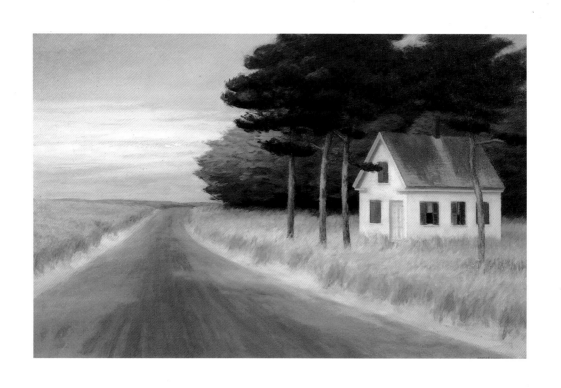

The Poetry of Solitude

A TRIBUTE TO EDWARD HOPPER

POEMS COLLECTED AND INTRODUCED BY GAIL LEVIN

UNIVERSE PUBLISHING, NEW YORK

First published in the United States of America in 1995
by UNIVERSE PUBLISHING
A Division of Rizzoli International Publications, Inc.
300 Park Avenue South
New York, NY 10010

Introduction and compilation ©1995 Gail Levin

95 96 97 98 99 / 10 9 8 7 6 5 4 3 2 1

Printed in Singapore

Library of Congress Catalog Card Number: 95-060812

Additional copyright notices are located on page 77.

PHOTO CREDITS
Art Resource 70
Geoffrey Clements 42, 52
Sheldon C. Collins 27
Neil Greentree 73
Melville McLean 58
Lee Stalsworth 22

Frontispiece: *Solitude,* 1944.
Opposite: *October on Cape Cod,* 1946.

Dedicated to Carl D. Lobell and Gloria Phares

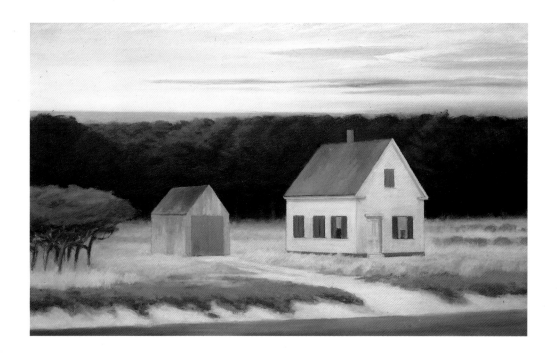

CONTENTS

This anthology would not have been possible without the talent and generosity of others, especially the poets whose work appears in it. I wish to thank not only all of them, but also the following persons who introduced some of them to me: Philip Appleman, Diane Bonds, Michel Boujut (whose 1986 novel, *Amours américaines* refers to Hopper), Debora Greger, Edward Hirsch, John Hollander, Lawrence Raab, John Van Sickle, and Grace Schulman, who helped in other ways as well. Additionally, I appreciate the assistance of Laural Weintraub, Rozanne Knudson, and the enthusiasm and encouragement of Mark Strand.

I am grateful as well to the many collectors and institutions who made it possible for me to reproduce works of art from their collections. In addition, I wish to thank Associated American Artists, Christie's, Lawrence A. Fleischman, Gagosian Gallery, Kennedy Galleries, Melissa Lazarov, the Susan Sheehan Gallery, Sotheby's, and Judith K. Zilczer for their assistance.

For their long encouragement and generous support of all of my work, I wish to thank Carl D. Lobell and Gloria Phares. With lively imagination, Charles Miers, publisher at Universe, joined with me to envision this volume. Also at Universe, my editor Claudia Goldstein, the book's designer Russell Hassell, Amelia Costigan, Bonnie Eldon, and Gladys Garcia have all contributed to the realization of this project. As I worked, I have benefited immeasurably from the advice, intelligence, wit, and love of my husband, John Van Sickle.

Gail Levin
New York City
February 19, 1995

Introduction

GAIL LEVIN

T HE THEMES OF POETRY AND SOLITUDE in the title for this volume reflect a deeply rooted and widely felt response to the work of Edward Hopper (1882–1967). Hopper himself gave the name *Solitude* to the scene of a silent house and empty road on Cape Cod that he painted in 1944, but already ten years earlier, as he was first winning wide public attention, the Chicago art critic C.J. Bulliet pronounced him "the poet in paint of loneliness" in an article captioned "Hopper Poet of Solitudes Just Deserted."[1] The "poetic insight" in Hopper's work had struck Horace Gregory, himself a poet;[2] Robert Coates in 1948 would write of Hopper's "poetry and momentousness,"[3] and Alexander Eliot evoked in 1955 the painter's "deeply poetic view of the world."[4] Shortly afterwards, Stuart Preston was to expand on the analogy, citing Hopper's "austere, detachedly poetic point of view" and comparing him to Robert Frost.[5]

Success was slow in coming to Edward Hopper. Growing up along the Hudson River in Nyack, New York, he showed great artistic promise. At art school in New York City, his fellow students (who included the future poet Vachel Lindsay) hailed him as the John Singer Sargent of the class. Then he faltered, enamored of French culture at a time when America was clamoring for an art of its own. Unable to settle on a style, he was forced to illustrate stories and advertisements for a living. He became embittered as more facile contemporaries flourished. Only after the age of forty did the taciturn Hopper begin to translate his inner experience into the spare images of urban New York and rural New England that won him recognition, coming to express for many the uneasiness and isolation of modern American life.

Hopper's celebrity had long since been secure when a retrospective show at the Whitney Museum of American Art in 1950 occasioned an article by his old friend, the painter Charles Burchfield. Under the title "A Career of Silent Poetry," Burchfield cited Hopper's "unflinching devotion to his inner vision" and "the element of silence that seems to pervade every one of his major works... or as someone has so aptly expressed it, 'listening quality'," asserting that "Hopper has caught the barrenness of certain phases of our contemporary life to a degree almost unendurable, or shown up a banality about it that could be very disturbing if he did not somehow stamp it with an interest of his own making."[6]

Meanwhile, confirming the critics' metaphorical assessment, poets responded to the singular moods

and considered forms of the paintings. In 1948, Constance Carrier could compare her own poetics with Hopper's artistic practice:

> A great deal is being written right now about a painter named Edward Hopper, and in a curious way much of it expresses what I am driving at in my own medium.... His work gives the effect of starting from reality, of passing through his emotional vision (which is reticent and restrained and yet strong enough to give each object its own mood), and of emerging without the absolute dogmatic finality which excludes the beholder. On the other hand, there seems to be in his painting no withdrawal into the nebulous or the wholly private symbol, which can exclude quite as completely.
>
> What I would like to do, and to grow better at doing, is what Hopper has done: make you see or hear or feel something: let you know, as unobtrusively and honestly as I can, what have been my reactions to it: and, finally, leave you room and reason for reactions of your own.[7]

Just three years later, in 1951, perhaps in the wake of the retrospective show that prompted Burchfield's essay, Samuel Yellen published what may be the first poem to mention Hopper, entitled "Nighthawks" and accompanied by the epigraph, "After the painting by Edward Hopper."[8] After seeing Hopper's last retrospective in Chicago in 1965, Lisel Mueller wrote "A Nude by Edward Hopper," which appeared in August 1967, just months after Hopper's death.[9] David Ray published "A Midnight Diner by Edward Hopper" in January 1970;[10] John Hollander published "Sunday A.M. Not in Manhattan" in 1971;[11] and the following spring, a small show in Pasadena inspired Tony Quagliano to write "The Edward Hopper Retrospective."[12]

It was also an exhibition that prompted Mark Strand, in the first of several interpretive essays, to write in 1971 of "a sense of being in a room with a man who insists on being with us, but always with his back turned."[13] Praising Strand's example and calling for more, John Hollander the next year issued a ringing challenge to reassess Hopper's meaning. He argued that Hopper should be seen as "a new American visionary," suggesting parallels with Emerson and bringing other poets and poetics into the discussion.[14] To illuminate *House by the Railroad*, Hollander said, "one could adduce E. A. Robinson's lines, 'They are all gone away,/ The house is shut and still,/ There is nothing more to say,' and have them apply to Hopper's pictures of all going away as well." Seeking to give a new definition to Hopper's aesthetics, Hollander cited Wallace Stevens, "In the metaphysical streets of the physical town."

Meanwhile, following the death of Hopper's widow in 1968, the more than 2,500 works in her bequest to the Whitney Museum had been awaiting disposition. Innocent of the protests raised by Hollander and others,[15] I was called by the Whitney in 1976 to be the curator of the Hopper Collection. With the zeal of a freshly minted art historian I began a systematic study, assembling the

documentation that in fact was lacking, producing a definitive catalogue of all the works, and presenting the results to the public through carefully orchestrated and interpreted shows with accompanying publications.

The show that I produced in 1979, "Edward Hopper: Prints and Illustrations," led the poet John Ashbery to write in a review that Hopper "turned his back forever on sophisticated Europe and, making virtue of necessity, embraced the homely American scene, which will always be indebted to him for having revealed its latent poetry."[16] For my subsequent show, "Edward Hopper: The Art and the Artist" in 1980, I organized a colloquium with art historians and artists and invited John Hollander to close with a word from the poets. He began with self-irony, invoking the possibility of a poet's "misprision of pictures," then went on to draw new and illuminating analogies between Hopper and the poetic theory and practice of Stevens, suggesting in fine that "Hopper's oeuvre might be named... 'The World as Meditation.'"[17]

In retrospect, it seems clear that this 1980 show greatly widened and deepened public awareness of Hopper. In the show I reconstructed for the first time his artistic development and intellectual context, capitalizing on my research as I digested and documented the materials of the Hopper bequest. The result was a wave of interest among a new generation of painters;[18] and the ensuing years have seen the comparable burst of poetic responses that I have been able to represent here only selectively. Nor has the wave crested. A judge in a recent national poetry contest tells me that numerous new poems in response to Hopper are being written.

Hopper works his way diversely into each imagination. In a recent letter, Hollander described his poem, "Sunday A.M. Not in Manhattan" as "a peculiar superimposition of an actual street scene from my childhood — Flatbush, in Brooklyn, on a winter Sunday at about noon, on frequent visits to a family who lived there — onto the Hopper Sunday morning painting, the truly Manhattan 'street scene', itself deriving in some way from the set for Elmer Rice's play, and surely not looking like a Manhattan street, but more like a Brooklyn one."[19]

Another of the poets represented here, William Carpenter, suggested to me that Hopper has "an emotional or aesthetic incompleteness (not failure!) in the image that demands completion in the other medium."[20] Again, it is the "listening quality" as reemphasized by Burchfield that interrogates and invites response. This lure to enter, then to parallel the scenes in words, attracted the French poet and critic Claude Esteban to compose in response to Hopper's paintings a cycle of prose meditations that closes with an intimation of the end of life, the painter's and the writer's.[21]

Recently Mark Strand has capped his early essays on Hopper, not through poetry, but with a monograph that concludes by evoking the "unset-

tling" silence of Hopper's rooms, noting: "We want to move on. And something is urging us to, even as something else compels us to stay. It weighs on us like solitude."[22] Strand, who studied painting for three years with Josef Albers at Yale before becoming a poet, has called Hopper the "most interesting and the most elusive American painter."[23]

In the course of writing the first biography of Hopper, I have uncovered evidence that he admired poetry all his life.[24] As a child, he read poets such as Coleridge and Kipling. As a teenager, he occasionally wrote poems himself. He illustrated a number of poems during his formative years (from Edgar Allan Poe to Victor Hugo to Thomas Hood) and teased his classmates in art school with limericks that he composed. Continuing to read poetry as an adult, he quoted poems, even in French, when he courted Josephine Nivison, an artist who knew and loved poetry. His presents to her were often volumes of poetry and he occasionally made up a rhyme to accompany his gifts. Sometimes he had a particular poem in mind when he painted; his favorites included poems by Goethe and Verlaine. He enjoyed the work of Robert Frost long before they came to know one another in the elect companionship of the American Academy of Arts and Letters.

This anthology presents a selection of the diverse and growing body of poems that Hopper's work has inspired. The poems range from rather general evocations of his art to quite specific readings of paintings. For some of the poets represented, Hopper's solitary images have suggested specific narratives, from the autobiographical to the fantastical. I have chosen poems that specifically refer to Hopper, while omitting others that appear to share certain themes or moods with his work. More than one critic has pointed out similarities to Hopper's art in the poetry of George Oppen.[25] Poems in his *Discrete Series* of 1932–34 contain some of the same spare imagery: the cars that pass "By the elevated posts And the movie sign" or the woman lying on her bed while the "Sun passes."[26] Such poems as Elizabeth Bishop's "Filling Station" or May Swenson's "Early Morning: Cape Cod" may reflect Hopper's influence. Bishop's line "ESSO—SO—SO—SO" recalls his 1939 painting *Gas* as well as *Portrait of Orleans*, a 1950 canvas with a prominent Esso sign.[27] Swenson's title brings to mind *Cape Cod Morning*, another of Hopper's 1950 paintings, while her vivid images of a "sail," "gulls," and "a snowy hull" suggest his 1944 nautical picture *The Martha McKeen of Wellfleet:*

> With creaking shears
> the bright
> gulls cut the veil
> in two,
> and many a clue
> on scalloped sail
> dots with white
> our double blue.[28]

Swenson often vacationed in or near Truro, where Hopper had a home, and she is known to have

owned postcards of his paintings.[29] No doubt the search could range even wider, but already the poets gathered here suffice to make the case that this profoundly reflective artist has stirred a lively new round in the ancient match between poetry and painting.

WORKS BY GAIL LEVIN FOR FURTHER READING

Those interested in more details about the role of poetry in Edward Hopper's life will want to read *Edward Hopper: An Intimate Biography* (New York: Alfred A. Knopf, 1995). In addition to sources cited in the notes that accompany the introductory essay in this volume, see the essays, extensive bibliography, exhibition history, and other reference data in *Edward Hopper: A Catalogue Raisonné*, fully illustrated in three volumes with a CD-ROM (New York: W.W. Norton & Co., Inc., 1995). For my discussion of working on Hopper, see "Biography & Catalogue Raisonné: Edward Hopper in Two Genres," (in *Biography and Source Studies*, II, AMS Press, New York, 1995).

Briefer bibliographies and good color reproductions can be found in *Edward Hopper: The Art and the Artist* (New York: W.W. Norton & Co., Inc., 1980), *Edward Hopper* (New York: Crown Publishers, Inc., 1984), and *Edward Hopper as Illustrator* (New York: W.W. Norton & Co., Inc., 1979). For reproductions of Hopper's graphic work, see *Edward Hopper: The Complete Prints* (New York: W.W. Norton & Co., Inc., 1979). My photographs of many sites painted by Hopper are available in *Hopper's Places* (New York: Alfred A. Knopf, 1985).

Shakespeare at Dusk, 1935

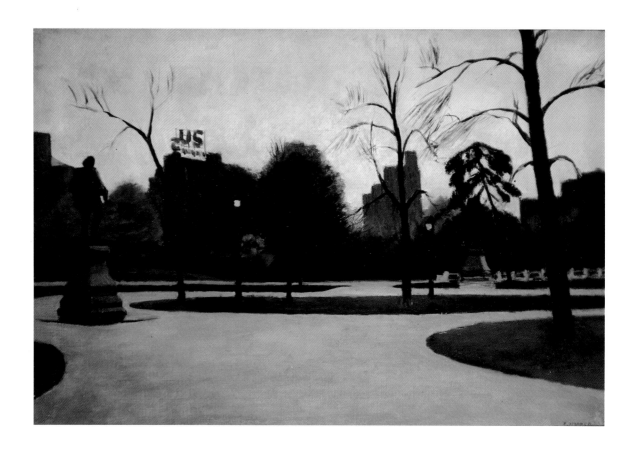

We should not be quite certain of the crystallization of the art of America into something native and distinct, were it not that our drama, our literature and our architecture show very evident signs of doing just that thing.[1]

The word life has in some artists' minds a relation to those greatly despised words, story and anecdote. In that all life is gesture and all gesture can be the basis for story or anecdote, there cannot be the slightest gesture or mood of nature that does not in a sense create anecdote.[2]

EDWARD HOPPER

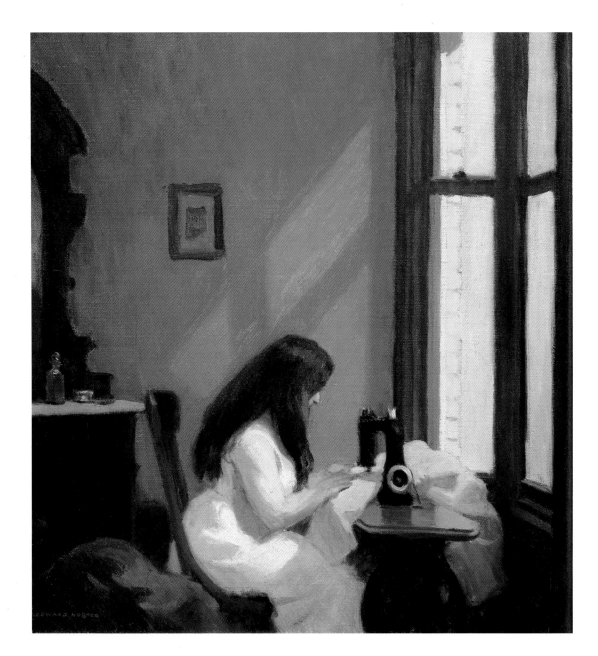

John Updike

Displayed in the Thyssen-Bornemisza Collection

The smaller, older *Girl at a Sewing Machine*
 shows her, pale profile obscured by her hair,
at work beneath an orange wall while sky

in pure blue pillars stands in a window bay.
 She is alone and silent. The heroine
of *Hotel Room*, down to her slip, gazes

at a letter unfolded upon her naked knees.
 Her eyes and face are in shadow. The day
rumbles with invisible traffic outside

this room where a wall is yellow, where
 a bureau blocks our way with brown and luggage
stands in wait of its unpacking near

a green armchair: sun-wearied, Thirties plush.
 We have been here before. The slanting light,
the woman alone and held amid the planes

of paint by some mysterious witness we're
 invited to breathe beside. The sewing girl,
the letter. Hopper is saying, *I am Vermeer.*

Girl at Sewing Machine, 1921

Larry Levis

EDWARD HOPPER, "HOTEL ROOM," 1931

The young woman is just sitting on the bed,
Looking down. The room is so narrow she keeps
Her elbows tucked in, resting, on her bare thighs,
As if that could help.

She is wearing, now, only an orange half-slip
That comes down as far as her waist, but does not
Console her body, which fails.
Which must sleep, by now, apart from everyone.
And her face, in shadow,
Is more silent than this painting, or any
Painting: it feels like the sad, blank hull
Of a ship is passing, slowly, the stones of a wharf,
Though there is no ocean for a thousand miles,
And outside this room I can imagine only Kansas:
Its wheat, and blackening silos, and, beyond that,
The plains that will stare back at you until
The day your mother, kneeling in fumes
On a hardwood floor, begins to laugh out loud.
When you visit her, you see the same, faint grass
Around the edge of the asylum, and a few moths,
White and flagrant, against the wet brick there,
Where she has gone to live. She never
Recognizes you again.

You sell the house, and auction off each thing
Inside the house, until

You have a satchel, a pair of black, acceptable .
Shoes, and one good flowered dress. There is a check
Between your hands and your bare knees for all of it —
The land and the wheat that never cared who
Touched it, or why.

 .

You think of curves, of the slow, mild arcs
Of harbors in California: Half Moon Bay,
Malibu, names that seem to undress
When you say them, beaches that stay white
Until you get there. Still, you're only thirty-five.
And that is not too old to be a single woman,
Traveling west with a purse in her gray lap
Until all of Kansas dies inside her stare. . .

 .

But you never moved, never roused yourself
To go down Grain Street to the sobering station,
Never gazed out at the raw tracks, and waited
For the train that pushed its black smoke up
Into the sky like something important. . .

And now it is too late for you. Now no one,
Turning his collar up against the cold
To walk past the first, full sunlight flooding
The white sides of houses, knows why
You've kept on sitting here for forty years — alone,
Almost left out of the picture, half undressed.

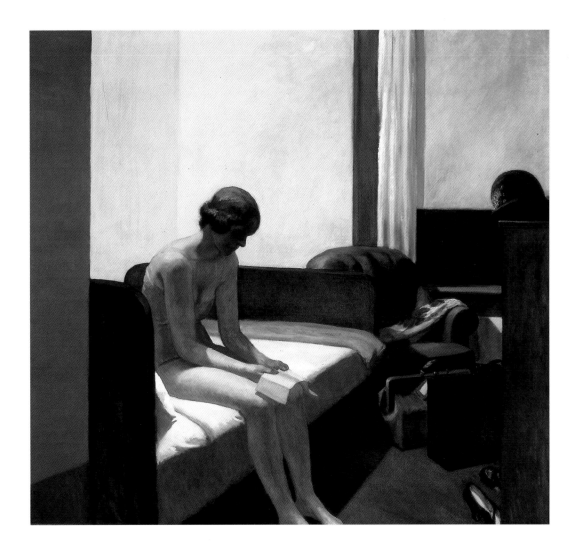

Lawrence Raab

AFTER EDWARD HOPPER

Usually it is night
but always there are windows.
And the green shades
in the rooms of small hotels
drawn halfway.
The carafe of water
on a heavy bureau.
And the woman
taking off her clothes.

The letter on the bed
beneath a picture of the ocean.
The yellow windows of the buildings.
Halfway through the afternoon
trees are drawn
to the edge of a field, and the light
in the rooms of houses by the sea
is still
almost perfectly white.

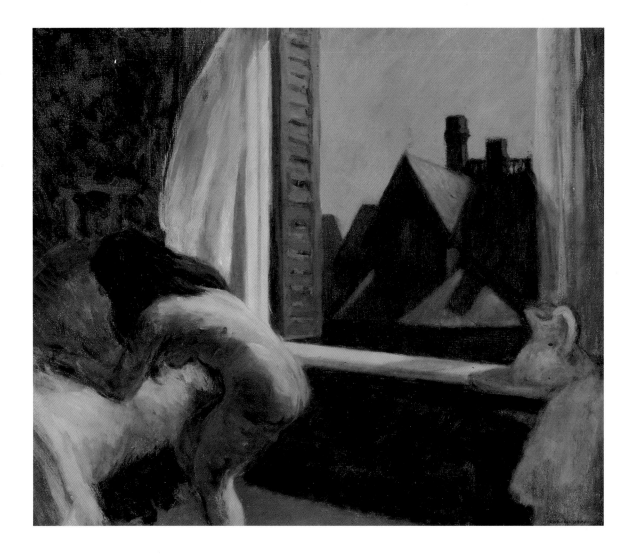

Eleven A.M., 1926

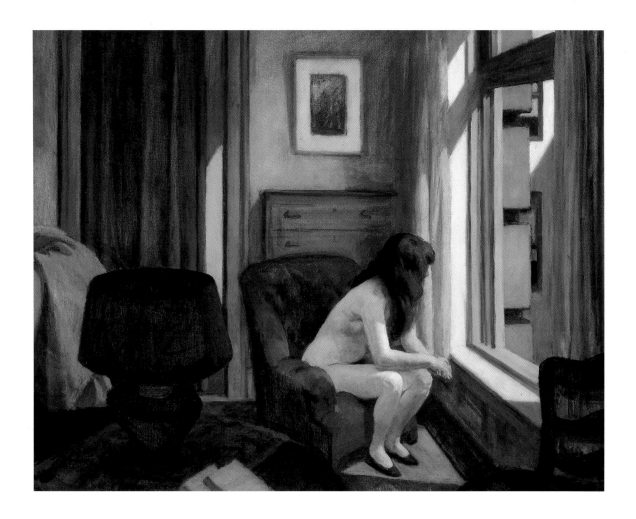

Stephen Dunn

IMPEDIMENT

"The loneliness thing is overdone."
—Edward Hopper, about responses to his work.

Except for shoes
the young woman is naked,
in a chair, looking out
a fully opened window,
her face obscured
by dark brown hair.
Apartment? Hotel?
Outside, the obdurate gloom
of city buildings.

It's 11 a.m.,
Hopper's title says,
time for her to have dressed
a hundred times.
It's the shoes which hint
of her desire to dress,
and of some great impediment.

Elbows on knees. Hands clasped.
The window she's leaning toward
is curtainless.
There's no sense she cares
she might be seen, or
that she wishes to show herself.

Robert Mezey

EVENING WIND

One foot on the floor, one knee in bed,
Bent forward on both hands as if to leap
Into a heaven of silken cloud, or keep
An old appointment — tryst, one almost said —
Some promise, some entanglement that led
In broad daylight to privacy and sleep,
To dreams of love, the rapture of the deep,
Oh, everything, that must be left unsaid —

Why then does she suddenly look aside
At a white window full of empty space
And curtains swaying inward? Does she sense
In darkening air the vast indifference
That enters in and will not be denied,
To breathe unseen upon her nakedness?

William Carpenter

EVENING WIND

The young model undressed before the poet
who stood with pen and notebook and made words
like lines, phrases like shadows in a woodcut.
He knelt her on the bed in the dollar hotel.
The damp city wind blew back the curtains;
she started up, her hair fell on her breasts,
her hand touched the mattress like a cat's foot.
He worked on metaphors. The evening window
was a white paper, smells entered like words
from the young city, the smell of the steam
railroad, the smell of the delicatessen
on Tenth Street, the smell of animals
carried through the streets. What did she hear
on the bleak wind? The room was full of senses.
There was a strange man behind her shadow.
It was the poet with his book of fear,
writing and writing in her intimate space.
She saw and covered herself.
She folded her head into her arms and wept.

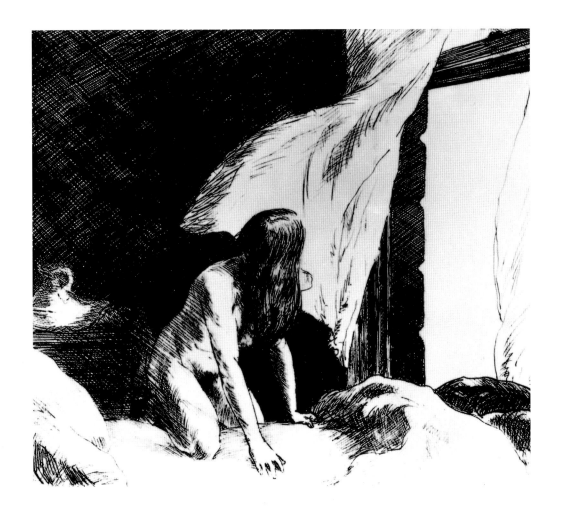

John Hollander

EDWARD HOPPER'S SEVEN A.M. (1948)

The morning seems to have no light to spare
For these close, silent, neighboring, dark trees,
But too much brightness, in low-lying glare,
For middling truths, such as whose premises
These are, and why just here, and what we might
Expect to make of a shop-window shelf
Displaying last year's styles of dark and light?
Here at this moment, morning is most itself,
Before the geometric shadows, more
Substantial almost than what casts them, pale
Into whatever later light will be.
What happens here? What is the sort of store
Whose windows frame such generality?
Meaning is up for grabs, but not for sale.

Seven A.M., 1948

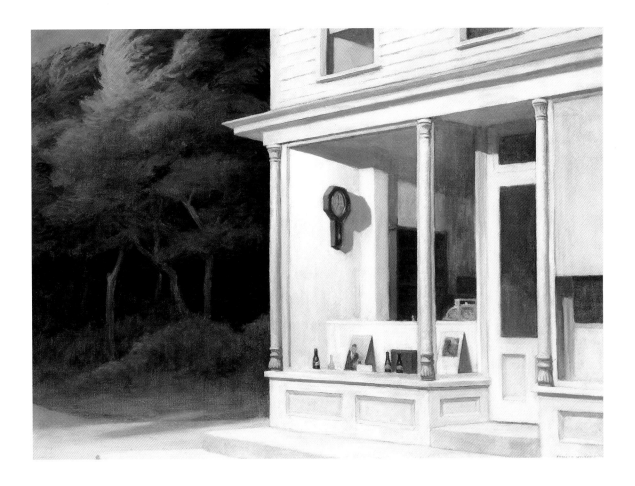

House by the Railroad, 1925

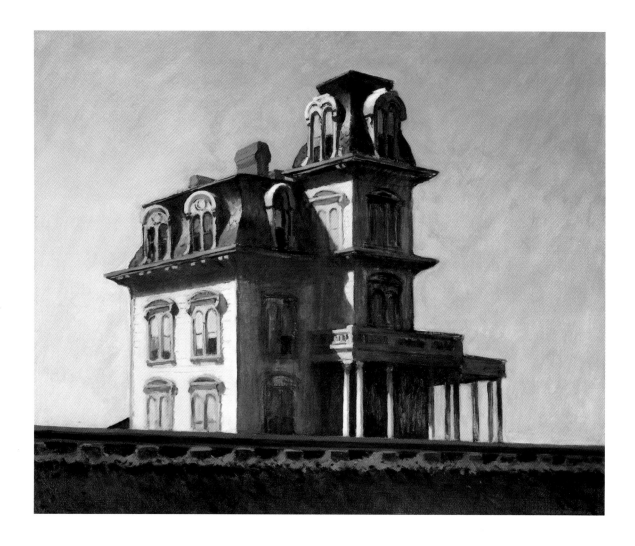

Edward Hirsch

EDWARD HOPPER AND THE
HOUSE BY THE RAILROAD (1925)

Out here in the exact middle of the day,
This strange, gawky house has the expression
Of someone being stared at, someone holding
His breath underwater, hushed and expectant;

This house is ashamed of itself, ashamed
Of its fantastic mansard rooftop
And its pseudo-Gothic porch, ashamed
Of its shoulders and large, awkward hands.

But the man behind the easel is relentless;
He is as brutal as sunlight, and believes
The house must have done something horrible
To the people who once lived here

Because now it is so desperately empty,
It must have done something to the sky
Because the sky, too, is utterly vacant
And devoid of meaning. There are no

Trees or shrubs anywhere — the house
Must have done something against the earth.
All that is present is a single pair of tracks
Straightening into the distance. No trains pass.

Now the stranger returns to this place daily
Until the house begins to suspect
That the man, too, is desolate, desolate
And even ashamed. Soon the house starts

To stare frankly at the man. And somehow
The empty white canvas slowly takes on
The expression of someone who is unnerved,
Someone holding his breath underwater.

And then one day the man simply disappears.
He is a last afternoon shadow moving
Across the tracks, making its way
Through the vast, darkening fields.

This man will paint other abandoned mansions,
And faded cafeteria windows, and poorly lettered
Storefronts on the edges of small towns.
Always they will have this same expression,

The utterly naked look of someone
Being stared at, someone American and gawky,
Someone who is about to be left alone
Again, and can no longer stand it.

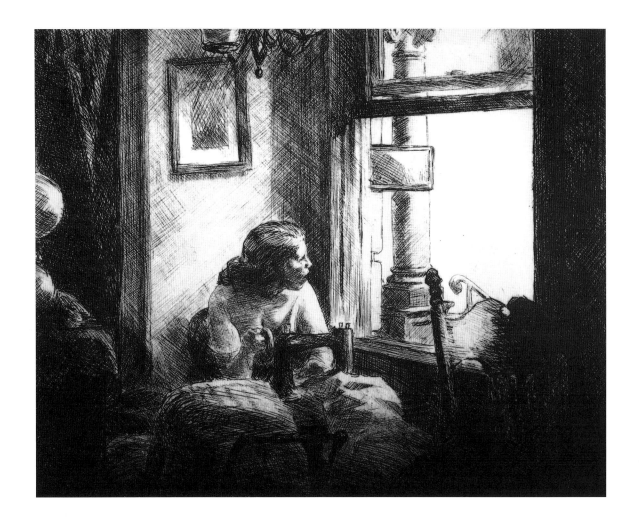

Sue Standing

HOPPER'S WOMEN

1. House by a Railroad

She minds the lilacs.
What can be saved, she saves:
dried flowers, tarnished costume jewelry,
half-used boxes of face-powder.
She imagines a man will call to her from the train:
"The fruits of summer are here!"
Sun pierces the house like the whistle
of the train. Inside she waits,
knitting the heavy light of afternoon.
A few pieces of Sandwich glass
glow in the windows.
The aspidistra, which never grows,
throws spiky shadows at her feet.

2. East Side Interior

She minds the cool
moonshine in the room.
In the frame of the window,
her soft profile, dark mass of hair,
she bends low, sewing.
Her African violets bloom all winter.

She thinks bones, she thinks rivers,
she thinks bread and yeast,
the way the white curtain
billows over the bed.
She will stay at the window through dusk
like a ghost at the sewing machine,
opaque and beautiful and lost.

3. Nighthawks

She minds her cheap gardenia perfume,
her tight red dress.
The way this reflection goes,
she sees only her angular arms
and the drugstore counter;
neon blots out the rest, except for fragments
of her dress mirrored on the coffee urn.
The men can't figure why she comes here,
night after night.
They haven't seen her room and won't.
She wonders why she can't leave
the harsh light of this town, wonders
if every town contains only two stories.

Samuel Yellen

NIGHTHAWKS

After the painting by Edward Hopper

The place is the corner of Empty and Bleak,
The time is night's most desolate hour,
The scene is Al's Coffee Cup or the Hamburger Tower,
The persons in this drama do not speak.

We who peer through that curve of plate glass
Count three nighthawks seated there — patrons of life:
The counterman will be with you in a jiff,
The thick white mugs were never meant for demitasse.

The single man whose hunched back we see
Once put a gun to his head in Russian Bank,
Whirled the chamber, pulled the trigger, drew a blank,
And now lives out his x years' guarantee.

And facing us, the two central characters
Have finished their coffee, and have lit
A contemplative cigarette;
His hand lies close, but not touching hers.

Not long ago together in a darkened room,
Mouth burned mouth, flesh beat and ground
On ravaged flesh, and yet they found
No local habitation and no name.

Oh, are we not lucky to be none of these!
We can look on with complacent eye:
Our satisfactions satisfy,
Our pleasures, our pleasures please.

David Ray

A MIDNIGHT DINER BY EDWARD HOPPER

Your own greyhounds bark at your side.
It is you, dressed like a Siennese,
Galloping, ripping the gown as the fabled
White-skinned woman runs, seeking freedom.
Tiny points of birches rise from hills,
Spin like serrulate corkscrews toward the sky;
In other rooms it is your happiness
Flower petals fall for, your brocade
You rediscover, feel bloom upon your shoulder.

And freedom's what the gallery's for.
You roam in large rooms and choose your beauty.
Yet, Madman, it's your own life you turn back to:
In one postcard purchase you wipe out
Centuries of light and smiles, golden skin
And openness, forest babes and calves.
You forsake the sparkler breast
That makes the galaxies, you betray
The women who dance upon the water.

All for some bizarre hometown necessity!
Some ache still found within you!
Now it will go with you, this scene
By Edward Hopper and nothing else.
It will become your own tableau of sadness
Composed of blue and grey already there.

Over or not, this suffering will not say Hosanna.
Now a music will not come out of it.
Grey hat, blue suit, you are in a midnight
Diner painted by Edward Hopper.

Here is a man trapped at midnight underneath the El.
He's sought the smoothest counter in the world
And found it here in the almost empty street,
Away from everything he has ever said.
Now he has the silence they've insisted on.
Not a squirrel, not an autumn birch,
Not a hound at his side, moves to help him now.
His grief is what he'll try to hold in check.
His thumb has found and held his coffee cup.

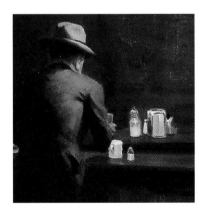

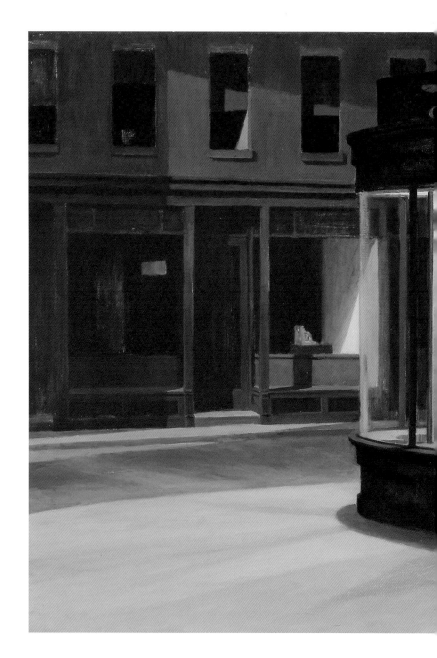

Nighthawks, 1942

Joyce Carol Oates

EDWARD HOPPER, "NIGHTHAWKS," 1942

The three men are fully clothed, long sleeves,
even hats, though it's indoors, and brightly lit,
and there's a woman. The woman is wearing
a short-sleeved red dress cut to expose her arms,
a curve of her creamy chest, she's contemplating
a cigarette in her right hand thinking
her companion has finally left his wife but
can she trust him? Her heavy-lidded eyes,
pouty lipsticked mouth, she has the redhead's
true pallor like skim milk, damned good-looking
and she guesses she knows it but what exactly
has it gotten her so far, and where? — he'll start
to feel guilty in a few days, she knows
the signs, an actual smell, sweaty, rancid, like
dirty socks, he'll slip away to make telephone calls
and she swears she isn't going to go through that
again, isn't going to break down crying or begging
nor is she going to scream at him, she's finished
with all that and he's silent beside her
not the kind to talk much but he's thinking

thank God he made the right move at last
he's a little dazed like a man in a dream —
is this a dream? — so much that's wide, still,
mute, horizontal — and the counterman in white
stooped as he is, and unmoving, and the man
on the other stool unmoving except to sip
his coffee but he's feeling pretty good,
it's primarily relief, this time he's sure
as hell going to make it work he owes it to her
and to himself Christ's sake and she's thinking
the light in this place is too bright, probably
not very flattering, she hates it when her lipstick
wears off and her makeup gets caked, she'd like
to use a ladies' room but there isn't one here
and Jesus how long before a gas station opens? —
it's the middle of the night and she has a feeling
time is never going to budge. This time
though she isn't going to demean herself —
he starts in about his wife, his kids, how
he let them down, they trusted him and he let

them down, she'll slam out of the goddamned room
and if he calls her SUGAR or BABY in that voice
she'll slap his face hard YOU KNOW I HATE THAT: STOP.
And he'll stop. He'd better. The angrier
she gets, the stiller she is, hasn't said a word
for the past ten minutes, not a strand
of her hair stirs, and it smells a little like ashes
or like the henna she uses to brighten it
but the smell is faint or anyway, crazy for her
like he is he doesn't notice, or mind —
burying his hot face in her neck, between her cool
breasts, or her legs — wherever she'll have him,
and whenever. She's still contemplating
the cigarette burning in her hand,
the counterman is still stooped gaping
at her and he doesn't mind that, why not,
as long as she doesn't look back in fact
he's thinking he's the luckiest man in the world
so why isn't he happier?

Ira Sadoff

HOPPER'S "NIGHTHAWKS" (1942)

Imagine a town where no one walks the streets.
Where the sidewalks are swept clean as ceilings and
the barber pole stands still as a corpse. There is no
wind. The windows on the brick buildings are
boarded up with doors, and a single light shines in
the all-night diner while the rest of the town sits in
its shadow.

In an hour it will be daylight. The busboy in the
diner counts the empty stools and looks at his
reflection in the coffee urns. On the radio the
announcer says the allies have won another victory.
There have been few casualties. A man with a wide-
brimmed hat and the woman sitting next to him are
drinking coffee or tea; on the other side of the
counter a stranger watches them as though he had
nowhere else to focus his eyes. He wonders if

perhaps they are waiting for the morning buses to arrive, if they are expecting some member of their family to bring them important news. Or perhaps they will get on the bus themselves, ask the driver where he is going, and whatever his answer they will tell him it could not be far enough.

When the buses arrive at sunrise they are empty as hospital beds — the hum of the motor is distant as a voice coming from deep within the body. The man and woman have walked off to some dark street, while the stranger remains fixed in his chair. When he picks up the morning paper he's not surprised to read there would be no exchange of prisoners, the war would go on forever, the Cardinals would win the pennant, there would be no change in the weather.

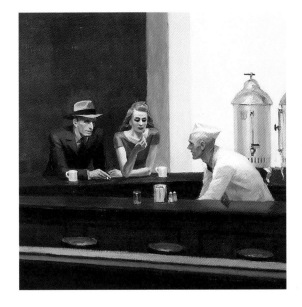

Susan Ludvigson

INVENTING MY PARENTS
After Edward Hopper's *Nighthawks*, 1942

They sit in the bright cafe
discussing Hemingway, and how
this war will change them.
Sinclair Lewis' name comes up,
and Kay Boyle's, and then Fitzgerald's.
They disagree about the American Dream.
My mother, her bare arms
silver under fluorescent lights,
says she imagines it a hawk
flying over, its shadow sweeping
every town. Their coffee's getting cold
but they hardly notice. My mother's face
is lit by ideas. My father's gestures
are a Frenchman's. When he concedes

a point, he shrugs, an elaborate lift
of the shoulders, his hands and smile
declaring an open mind.

I am five months old, at home with a sitter
this August night, when the air outside
is warm as a bath. They decide,
though the car is parked nearby,
to walk the few blocks home, savoring
the fragrant night, their being alone together.
As they go out the door, he's reciting
Donne's "Canonization": "For God's sake
hold your tongue, and let me love,"
and she's laughing, light
as summer rain when it begins.

John Stone

EARLY SUNDAY MORNING

Somewhere in the next block
someone may be practicing the flute
but not here

where the entrances
to four stores are dark
the awnings rolled in

nothing open for business
Across the second story
ten faceless windows

In the foreground
a barber pole, a fire hydrant
as if there could ever again

be hair to cut
fire to burn
And far off, still low

in the imagined East
the sun that is again
right on time

adding to the Chinese red
of the building
despite which color

I do not believe
the day
is going to be hot

It was I think
on just such a day
it is on just such a morning

that every Edward Hopper
finishes, puts down his brush
as if to say

As important
as what is
happening

is what is not.

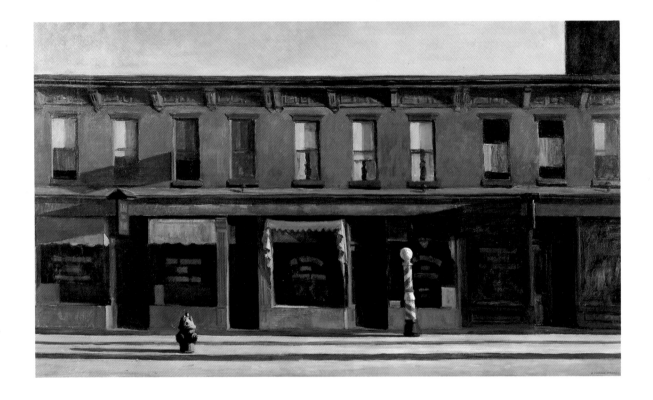

John Hollander

SUNDAY A.M. NOT IN MANHATTAN

Across the street: closed shops
Where glass reflects this wide
Light only, or faintly
Etched on the sky, trolley
Lines that the overhead,
Half-open windows are
Thinking. Long, slant shadows
Cast on the wan concrete
Are of nearby fallen
Verticals not ourselves.
Lying longest, most still,
Along the unsigned blank
Of sidewalk, the narrowed
Finger of shade left by
Something, thicker than trees,
Taller than these streetlamps,
Somewhere off to the right
Perhaps, and unlike an
Intrusion of ourselves,
Unseen, long, is claiming
It all, the scene, the whole.

Tony Quagliano

EDWARD HOPPER'S
"LIGHTHOUSE AT TWO LIGHTS," 1927

"The world about us would be desolate
except for the world within us."
—Wallace Stevens

a white lighthouse in the hard flat
white light of Maine
projected above the white clapboard

outbuildings, the dwellings
of the lighthouse man
bright on the hard coast

one warmer yellow house also
with an empty dark central window
a bit of low watery foliage

one brown chimney smokeless in summer
and in all, open empty windows
open empty doors

no one is pictured there
not in any of the doors
or any of the windows

where at most they would be between
the internal and external worlds
no one there to see what ships

go by at Two Lights
and for anyone on shipboard
no one there to be seen

Captain Upton's House (detail), 1927

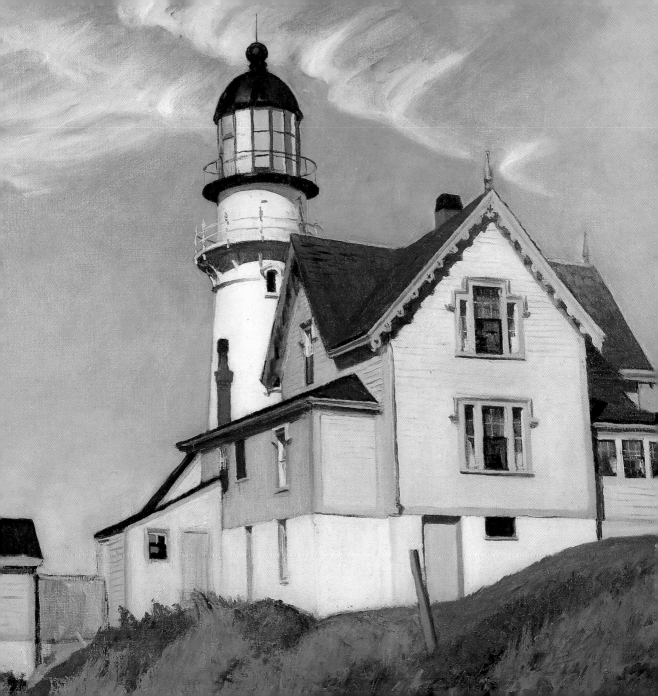

Lisel Mueller

A NUDE BY EDWARD HOPPER
For Margaret Gaul

The light
drains me of what I might be,
a man's dream
of heat and softness;
or a painter's
— breasts cozy pigeons,
arms gently curved
by a temperate noon.

I am
blue veins, a scar,
a patch of lavender cells,
used thighs and shoulders;
my calves
are as scant as my cheeks,
my hips won't plump
small, shimmering pillows:

but this body
is home, my childhood
is buried here, my sleep
rises and sets inside,
desire
crested and wore itself
thin
between these bones —
I live here.

Girlie Show, 1941

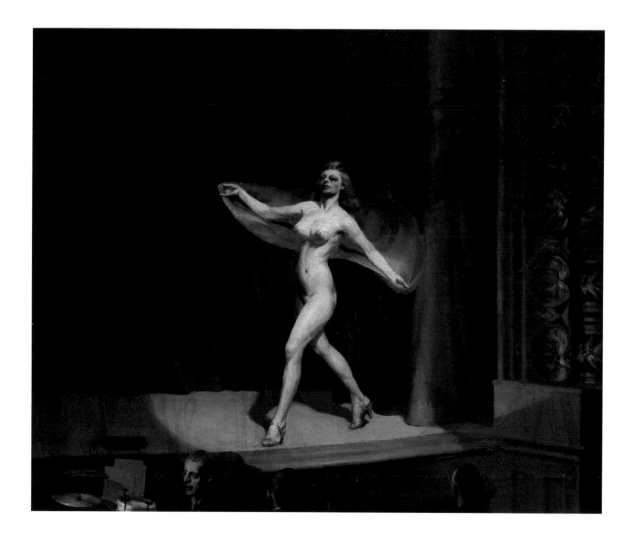

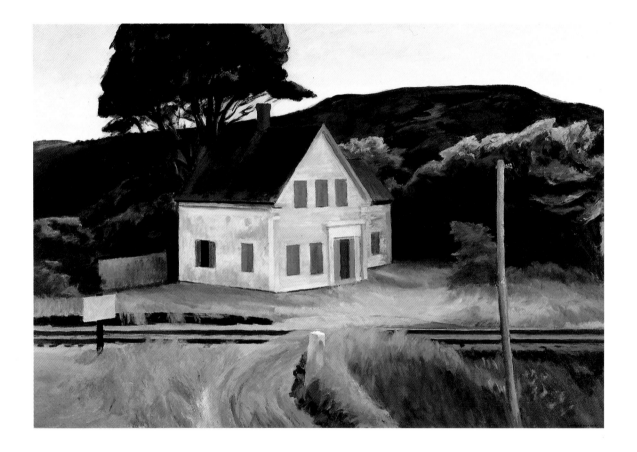

Anthony Rudolf

EDWARD HOPPER

Objectivists are metaphysical.
Over against the stillness of the house
what is not still need not be on the move.
And yet, upon my word, the absence moves
to the presence, by the railroad, of the house.
Reality? No way into this house
that is nothing but a structure of his mind
painted alone because it was not there.

William Carpenter

NIGHT SHADOWS

A man traveled in Europe among Fauves
and Cubists, then returned to his hotel
and slept. He woke at midnight.
He opened the window and looked down
at a cigar store with its mansard windows
covered with awnings like heavy lids
over the eyes, as if the building were a face,
watching him walk into that white corner.
His shadow rose behind him, like an animal
becoming human, a black bear walking
from the darkness towards a furnished room
where, when the door opened, there would be
a family of shadows, there would be a light.

Night Shadows, 1921

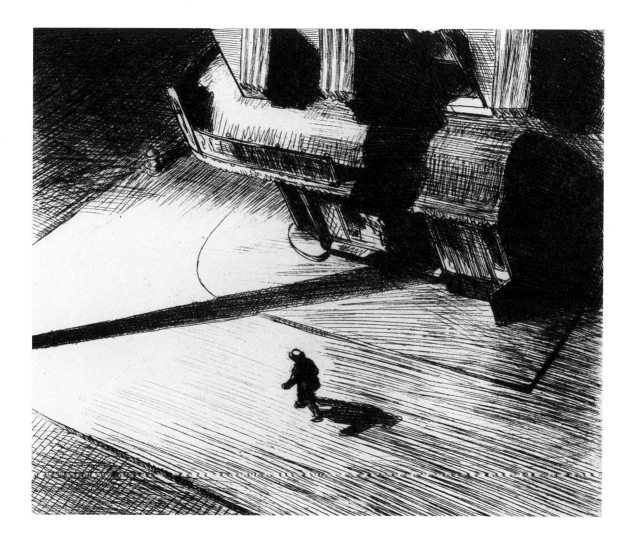

Cobb's Barns, South Truro, 1931

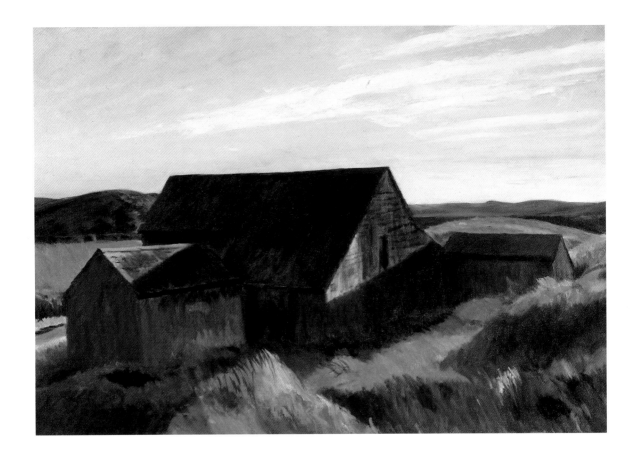

Anne Babson Carter

COBB'S BARNS

Hopper painted this one empty of people.
From a ridge of dunes he saw
what someone else had built,
a set of barns attached
in the way a child's might be,
with each side seasoned a different
chromatic red — it being South Truro
and exposed, predictably,
to the permeability of air.
 "There are many thoughts,
 many impulses, that go into
 a picture," Hopper once wrote,
 but he chose buildings not for beauty.

He caught the light that mattered
on the three planes
of the three roofs,
then provided solitude
where cows and other mud-bearing animals
are found. Hopper liked
the hills to look purple,
and he made the grasses common —
indigenous, they were given, therefore,
to a certain wildness.
A haze off the ocean is understood.

"My aim," he told his wife,
"is the most exact
transcription possible."

By deed these barns belonged
to A.B. Cobb, unknown man,
until a painter's eye
in the summer of 1931,
transferred ownership to himself,
and Cobb, in death, to immortality.
 (Look what) can be done
 with the homeliest subject,
 if one possesses a seeing eye,
 they said of Hopper.

Did these giant forms filling their space
on sand, like dinosaurian blocks,
fill an absence in Hopper as well?
 In the deliberate heat
 of a Cape Cod summer,
 as he divided the soil
 of his canvas with Cobb,
 Hopper allowed,
 "I don't know what my identity is."

All quotations are from *Edward Hopper:
The Art and the Artist*, by Gail Levin

• 5 3 •

David Ray

AUTOMAT

One at one table,
one at another.

Her stray hair is stroked
(by her). He reads Wall St.

It's quite classic —
separate tables

brass glistens on,
polished spittoons

and reflected lights
a highway out to hell,

black as hell.
Extent of human reach, nihil,

and loneliness burning loud
like lamps left on

Automat, 1927

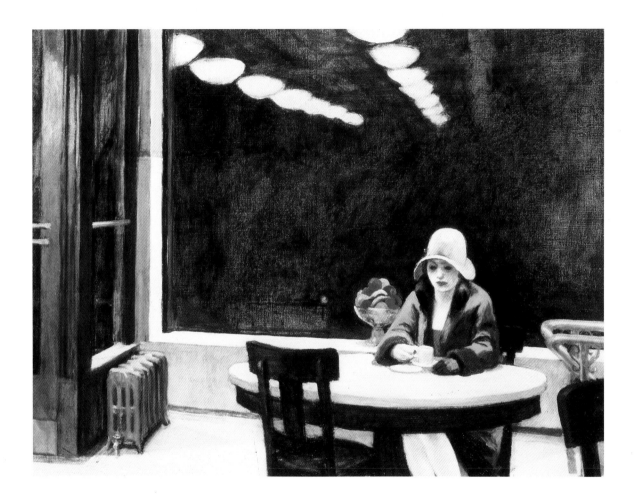

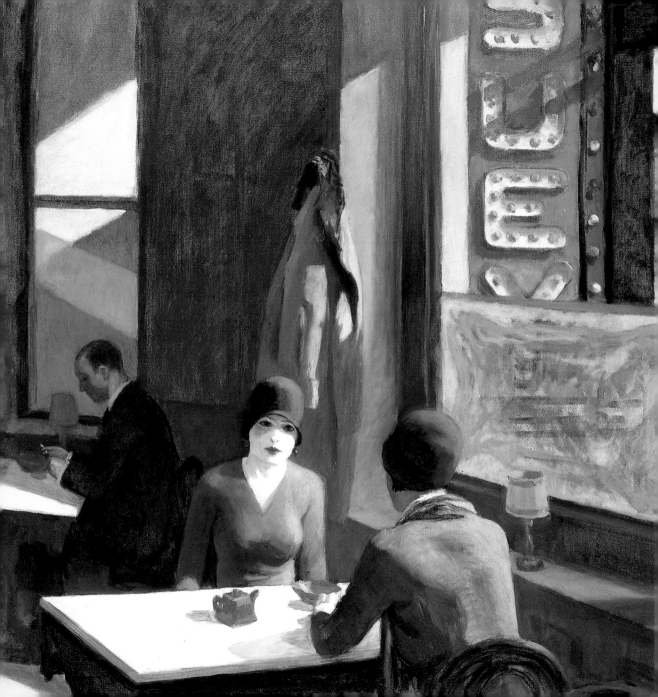

W.R. Elton

HOPPER: IN THE CAFÉ

dawn:
the figures crouch

in the red-vinyled Greek greasy spoon
across the street is Sal's Pizza

and next to it C & H Wine and Liquor Center

who are these people
moved by what dream

actors hired for the scene
papier-mâché

engaged in conversation and contemplation
some white and some black

between them in the aisles
Spiro the waiter
runs around

like

a wound-up white mouse

Chop Suey (detail), 1929

Pemaquid Light, 1929

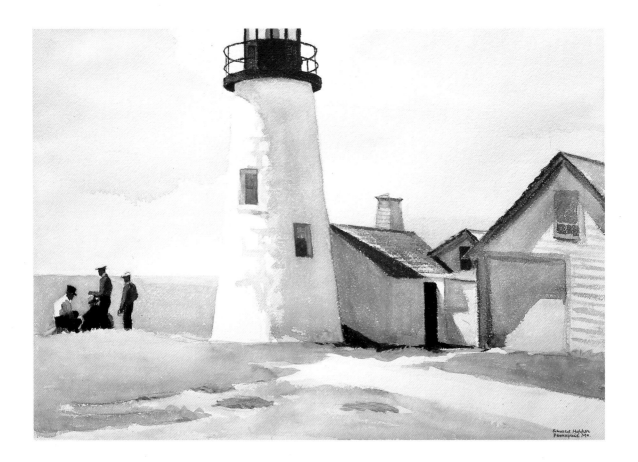

Ira Sadoff

FEBRUARY: PEMAQUID POINT

The lighthouse as an image
of loneliness has its limits.

For as we stand on the shore
of this ocean, the crusted snow

on the hills and grass
dispersed beneath it, that tower

seems a place where people gather
some vision of themselves: the marriage

of rock to water, of wave to snail
washed up on shore. We're small,

and waving to the lobster boat —
which could be miles away or close

enough to raise our voices to — makes
us wish our journeys took us further,

past witness, to a scene
where we belonged. A man in blue

pulls up his net, tiny fish
swim free of it. And the man

pulling anchor, whose strength
pulls him further from the shore,

pays tribute to our rootlessness.
As he shouts to start the engine up,

to take his course, he leaves us
in the distance, the repeated ritual

of his wake. And like the water
stirred against the lighthouse wall,

breaking up, wave after wave, we
forget ourselves. Learn our place.

Grace Schulman

AMERICAN SOLITUDE

Hopper never painted this, but here
on a snaky path, his vision lingers:

Three white tombs, robots with glassed-in faces
and meters for eyes, grim mouths, flat noses,

lean forward on a platform like strangers
with identical frowns scanning a blur,

Study for Portrait of Orleans, 1950

far off, that might be their train.
Gas tanks broken for decades face Parson's

smithy, planked shut now. Both relics must stay.
The pumps have roots in gas pools, and the smithy

stores memories of hammers forging scythes
to cut spartina grass for dry salt-hay.

The tanks have the remove of local clammers
who sink buckets and stand, never in pairs,

but one and one and one, blank-eyed, alone,
more serene than lonely. Today a woman

rakes in the shallows, then bends to receive
last rays in shimmering water, her long shadow

knifing the bay. She slides into her truck
to watch the sky flame over sand flats, a hawk's

wind arabesque, an island risen brown
Atlantis, at low tide; she probes the shoreline

and beyond grassy dunes for where the land
might slope off into night. Hers is no common

emptiness, but a vaster silence filled
with terns' cries, an abundant solitude.

Nearby, the three dry gas pumps, worn
survivors of clam-digging generations,

are luminous, and have an exile's grandeur
that says: in perfect solidude, there's fire.

One day I approached the vessels
and wanted to drive on, the road ablaze

with dogwood in full bloom, but the contraptions
outdazzled the road's white, even outshone

a bleached shirt flapping alone
on a laundry line, arms pointed down.

High noon. Three urns, ironic in their outcast
dignity — as though, like some pine chests,

they might be prized in disuse — cast rays,
spun leaf-covered numbers, clanked, then wheezed

and stopped again. Shadows cut the road
before I drove off into the dark woods.

Sidney Wade

GAS

—*after Edward Hopper*

The lonely man
 performs some necessary ritual
 behind a pump. We cannot tell
exactly what it is he does because
 the angle is so odd. A rack of cans

of oil between
 two pumps on the island stands, as they al-
 ways do, conveniently avail-
able, in easy reach of any needy
 motorist. The light is low, and the trees,

massed heavily
 behind the man and his pumps, march darkly
 off to the right. A modest shock
of roadside weeds attends the greenery
 as it condenses. On the periphery,

out of our ken,
 shines a source of artificial light. We
 are meant to feel the clutch of the
evening. It is not benevolent.
 The artist has invested his talent

in loneliness.
 The values and the crusty inflections
 of his particular diction
demonstrate devotion to the modest
 fears of the soul in the longest moments

of late after-
 noon. A sign hangs white above the station.
 Mobilgas and Pegasus. A
flag of sorts, a standard, here, to more
 than gas. The language, though hard, is clear.

Gas, 1940

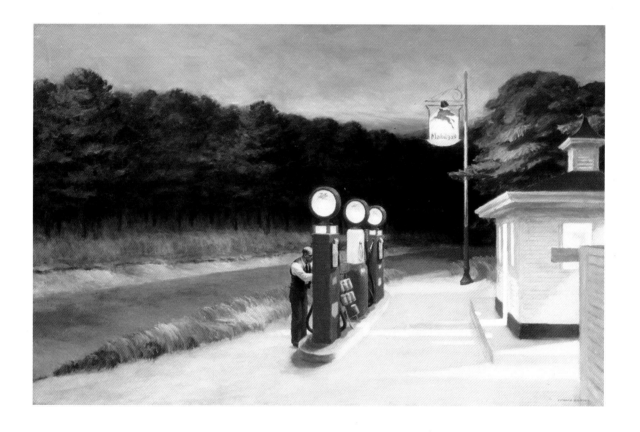

Tony Quagliano

THE EDWARD HOPPER RETROSPECTIVE

The man's dead
so I suppose that any looking
at the paintings
must be backwards
though I read someplace that
even when alive, he often held
the paintings back
unsigned, few dates
stuck in back rooms
didn't say much about it
never spoke much at all
married late, precipitating
his sensual period
painted the wife a few times
and let her do the talking
when the guests dropped by.

Today in Pasadena, two earnest gents
with full gray heads
one electric as Einstein's
both in shirts and slacks pressed
sharp and clean as the neighborhood Chinese
could squeeze it
scuttle and murmur through this gallery.
Old Left, I figure

readers of Fearing
totalling between them maybe
six or eight votes for Norman Thomas.
"He said it right in this one,"
one gent says
and the other nods
and they both stand there
looking and nodding
at a barren gas station
on the wall in Pasadena—
and I'm thinking
what do these gray gents see
that famous Hopper loneliness
some moody Americana?
do they picture Tom Joad stopping for a fill-up?
Dillinger knocking over the joint for pocket money?
what did Hopper trigger right in that one
something from a film or book?
or some gas station they remember
thirty, forty years ago.

That solitary painter, these eminent gents
an art museum in Pasadena.
I try to find
the proper retrospective.

Four Lane Road, 1956

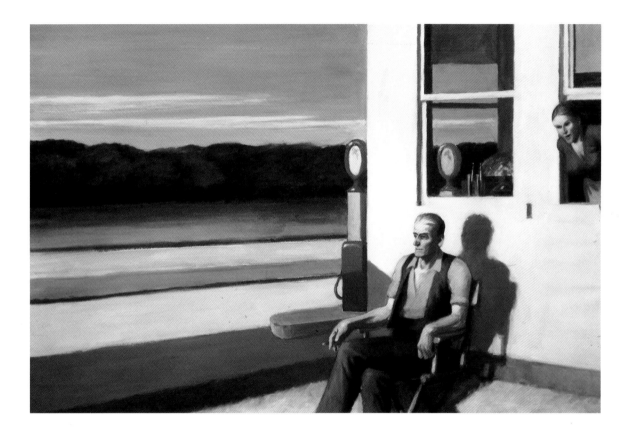

Marianne Boruch

LIGHT
—after Edward Hopper

which is not thought, but the airless stare
furrowing its welcome like the inevitable hot
misery of summer. We step in
and out of it. We watch it flood the porch, slice down
hard, windows onto floors. The cat crosses
flares up in angles. And always
someone doing nothing in it. So far away
is darkness, its busy cool imaginings
 under stone or brick
or think, darkness for years
under the Federalist house. No mural inside
can draw that splendid inkwell up
although the mural weeps where boats
pretend to anchor, and the harbor narrows
two centuries against the impending mob. Distance,
until a man is a drop of paint, a child

bare gem of color, chipped now
some other shape rages, unimaginable toy.
What I wanted, Hopper wrote, *was to paint
sunlight on the side of a house.*

 But they sleepwalked
for him, their faces beamed up like ice floes, men
and women stunned by circumstance, vacant
as moons. Here
a man on the side of the bed
wakes to nothing. Here a woman floats, dim sentry
at the great bay window. Was it a fine
viciousness, or kindness
that did this? Even the sea is stilled,
its blue the blue
of an eye that will neither waver nor blink
nor recognize in the light, a source of light.

Summer Evening (detail), 1947

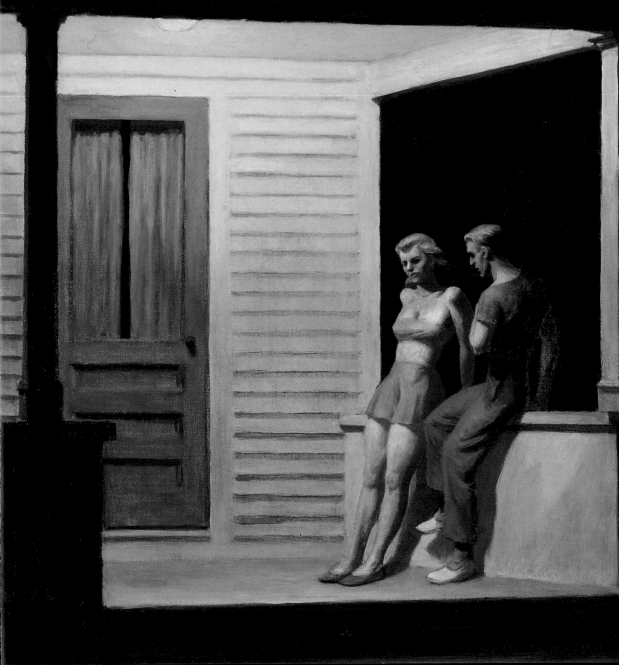

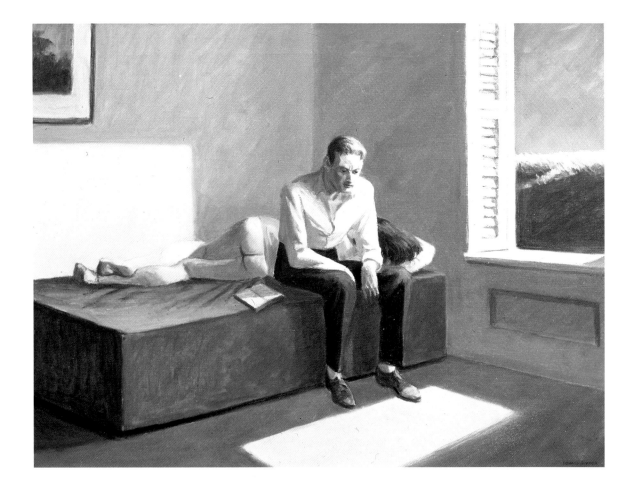

Debora Greger

THE MAN ON THE BED

In late September 1958, I visited his South Truro studio
and saw on the easel not an unfinished painting, not even
a stretched canvas, but a large empty stretcher. "He's
been looking at that all summer," Jo Hopper said.

—Lloyd Goodrich, of Edward Hopper

He lay on the bed, thinking
of what he could see from the window
as a little landscape of failure,
glittering after the rain,
the roses within reach but rusted,
a red bird lost in the thick
wet leaves of the oak,
the tree, caught in mirrors, shaking.
He lay on the bed,
his shirt turning blue with evening,
thinking, in the dark a red bird
might as well be black.

He slept then
and dreamt of a man

who slept with his glasses on,
the easier to find them when he woke.
The room seemed smaller,
the wind against the corner
of the house stronger.
If the heart is a house, he thought,
it is rented to strangers
who leave it empty.
If the heart is a house,
it is also the darkness around it
through which a black bird flies, unseen,
and unseeing, into the window,
beating and beating its wings
against the glass.

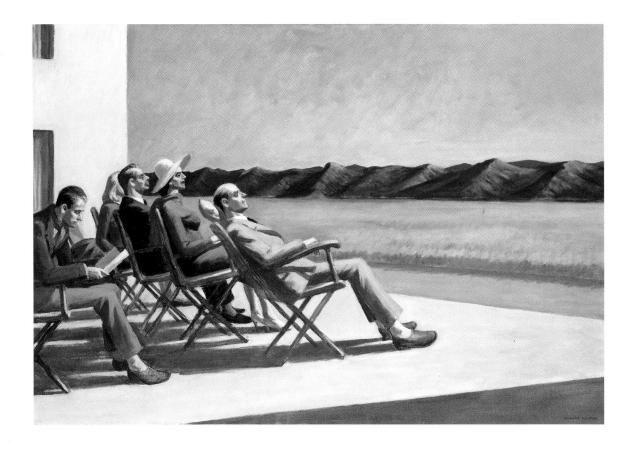

Diane Bonds

THE LIFE OF THE BODY
(Edward Hopper's *People in the Sun*, 1960)

You could call it abandon but never leisure:
their relinquishment of motion and interchange.
Wooden as their chairs, and arranged
with the same precision, obsessive and
mathematical, these people might be seeds
tensely waiting the resistless pull of light
toward their own unfolding. And why not?
Haven't we all seen miracles?

Perhaps they believe in the incongruity
of ends and means, and submit to the sun
without a prayer for transformation, reasoning
no myth arises out of nothing: that the same
shower of gold in which the hero was conceived
draws forth the grass — an ocean of it, a whole
prairie — impinging on the oddly misplaced
pavement where they sit.

No, you couldn't call it leisure, but you might
call it longing — longing so strong it poses
as necessity, which is easy to confuse
with resignation. That is why they are
unsettling, offering their bodies to the sun
yet making no concessions to the circumstance
(unless you count the woman's wide-brimmed hat).
You must take us as we are,

their bodies seem to say, uncompromising in
their good street clothes — gray-flannel suits,
wingtips, blue frocks, high-heeled pumps.
It is enough that we have brought ourselves
to this brink, arrayed ourselves opposite
the distant mountains, surrendered haste
to rest in this harsh chilly light
in the wilderness. And perhaps

they imagined the close-cropped plain, the blue-
knuckled granite — then vision failed and they
were locked in their bodies on the rim
of a dream. In the foreground, two men extend
their legs at exactly the same angle, exposing
bare ankles. Some hurt, freshly unbandaged,
would be less shocking. Yes, I think we have
to say that they have courage, to face

a vast emptiness that brims with light: no wonder
they seem mannequins slung in seats awaiting
lift-off. At the center, one man is cradled
in his chair like Jesus in an inept Pietà —
motherless, wounds hidden. How stubborn
this figure is, as if his garments might be
burned away, his body healed; yet how
literal, as if all flesh were grass.

Lisel Mueller

AMERICAN LITERATURE

Poets and storytellers
move into the vacancies
Edward Hopper left them.
They settle down in blank spaces
where the light has been scoured and bleached
skull-white and nothing grows
except absence. Where something is missing,
the man a woman waits for
or furniture in a room
stripped like a hospital bed
after the patient has died.
Such bereft interiors
is just what they've been looking for,
with their lumpy beds,
their birdcages and decks of cards,
their dog-eared books, their predilection
for starting fires in empty rooms.

Sun in an Empty Room, 1963

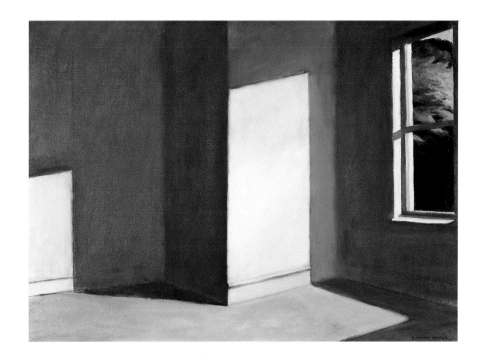

Simon Cutts

From *Pianostool Footnotes*

On parquet
sunlight

solidifies
its polished

petals*

*Edward Hopper 1882–1967

Alan Williamson

THE LIGHT'S READING
Meditations on Edward Hopper

1

On Sundays, from upstairs, a grown man's voice:
"I love it I love it I love it I love it Yay
Patriots!"

 What do they love? Or the women's spooky
enjoyment of pity: "Isn't that the way..."

A man's voice falling, in a hotel corridor, "Yes,
dear, I'm going..."

 Everywhere we fail
to snatch it back off the mirror, this endless falling
of life that only
lives to keep itself going: impenetrable scrim...

2

The light's reading of us: by definition, ending
where it begins, like a clockface...at times
endlessly fertile and opening — the sun
presses the girl's crisp summer dress back like wind
where she waits at the hot curb,
and you feel behind her every hoarded coolness
of the dim apartments.

 But always, come August,
the shadows are folded away; then something happens
in the color of the sky, like a trumpet, calling
to the bronze in things: the leaves, the purple horsetails
of the marshgrass, the crazy shingled houses.

Then the fattish girl comes out in her bikini
to sun, once more, on the rail of the upstairs porch,
her mother knitting behind...

It is all in her silly, hopeful look out against
where the painting looks: evening blue
distilled in the roofs; the empty room behind her,
where the sun's rim only reaches the white border
of the picture on the wall; and all the mother is keeping
herself from saying...

 the light, like a reader, in love with fate.

3

The man sleeps, his back a shell.
 The woman, able to bear more —
if only to bear how much they have desired
each wide-pored, graying other —
 is sitting up.

He seems to float among monoliths: the walls
thickened with what — mere dusk, a hidden airshaft,
closets, plumbing? —

One sees past every wall to another window.

Inexplicable fear of falling: the ringed horizon,
the eternal smokestacks —

So desire towers, and, towering, holds us
over what is beyond any
object: the empty clockface, the rims of time.

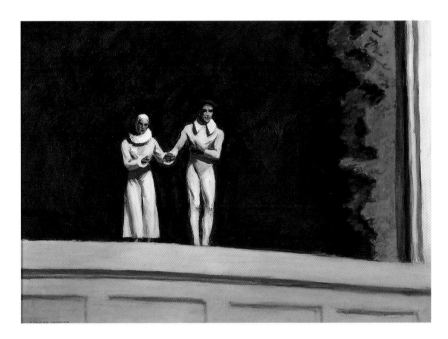

Two Comedians, 1965

4

A man who loves only one woman in his life
empties the space around him with rejected
dreams.

 It is the shock of their going opens
the air as far as death. The people there
look strange, in that long light: at first, more rigid
than the damned in hell; then the rays find a richness
of old metal in the wrinkles, a smile in the sag of the breast —
shimmer of the impenetrable, the pure cells...

Was this love, or simply knowledge of the planet
of his cropped head, what life it would bear? — that kept
the picture from filling

with young girls or children, only these two
comedians, the pancake stiff on their faces,
the smiles stiffly waiting to say good-bye...

Yet how delicately he paints her vanishing
to him, at the moment when she stands most lovably
still before life. The sky
is behind her wholly. The frame does not let one follow
her arm even as far as the flex to move
her paintbrush. Her look is gone
into whatever has caught it, leaving only
a sidelong spill of light off the lens of the eye.

Notes

1 C.J. Bulliet, "Hopper Poet of Solitudes Just Deserted," *Chicago Daily News*, January 6, 1934, p. 28.

2 Horace Gregory, "A Note on Hopper," *The New Republic*, 77, December 13, 1933, p. 132.

3 Robert Coates, "The Art Galleries: Edward Hopper and Jackson Pollock," *The New Yorker*, January 17, 1948, p. 56.

4 [Alexander Eliot], "Gold for Gold," *Time*, May 30, 1955, p. 72.

5 Stuart Preston, "Art: Award to Hopper," *The New York Times*, December 16, 1960, p. 45.

6 Charles Burchfield, "Edward Hopper: Career of Silent Poetry," *Art News*, 49, March 1950, p. 16.

7 Constance Carrier, "From the Prize Winners," in *Poetry Society of America Official Bulletin*, February 1948, pp. 7–8.

8 Samuel Yellen, "Nighthawks," first appeared in *Commentary*, 12, November 1951, p. 436.

9 Lisel Mueller, "A Nude by Edward Hopper," *Poetry*, 110, July 1967, p. 226.

10 David Ray, "A Midnight Diner by Edward Hopper," *Poetry*, 115, January 1970, pp. 242–43.

11 John Hollander, "Sunday A.M Not in Manhattan," in *Poetry*, 118, August 1971, pp. 267–68, reprinted in John Hollander, *The Night Mirror* (New York: Atheneum, 1971).

12 "Edward Hopper: Fifteen Paintings" traveled to Pasadena from March 4 through April 30, 1972.

13 Mark Strand, "Crossing the Tracks to Hopper's World," *The New York Times*, October 17, 1971, Section 2, p. 26.

14 John Hollander, "An American Painter," review of *Edward Hopper* by Lloyd Goodrich (New York: Harry N. Abrams, 1970), *Commentary*, January 1972, pp. 94–99, in a scathing attack that amounts to a manifesto for a whole new way of seeing the artist. Hollander also denounced "the lack of responsible scholarly apparatus" as a bar to adequate understanding of the artist.

15 For example, Hilton Kramer, "A nine-pound monument," *The New York Times Book Review*, November 21, 1971, pp. 72–73, also reviewing Goodrich, described his book as belonging to the history of Hopper's public "success rather than to the effort to penetrate what lay behind it."

16 John Ashbery, "Edward Hopper in Full range of styles is coming to the Whitney," *New York*, September 22, 1980, p. 38.

17 John Hollander, "Hopper and the Figure of Room," in *Art Journal*, 41, summer 1981, p. 160.

18 See Gail Levin, "Edward Hopper: His Legacy for Artists," in *Edward Hopper and the American Imagination* (New York: W. W. Norton for the Whitney Museum of Art, 1995).

19 John Hollander to the author, letter of May 19, 1994; he alludes to my discovery that Hopper loved Jo Mielziner's set for *Street Scene*, which he saw not long before painting *Early Sunday Morning*. See Gail Levin, *Edward Hopper: The Art and the Artist* (New York: W.W. Norton & Co., 1980) pp. 57–58.

20 William Carpenter to the author, letter of February 14, 1995.

21 Claude Esteban, *Soleil dans une place vide* (Paris: Flammarion, 1993).

22 Mark Strand, *Edward Hopper* (Hopewell, N.J.: The Echo Press, 1994), p. 59.

23 Mark Strand, quoted in John Blades, "Point of View," *Chicago Tribune*, January 25, 1993, section 2, p. 3.

24 Gail Levin, *Edward Hopper: An Intimate Biography*, New York: Alfred E. Knopf 1995.

25 See Allen Kimbrell, "*Of Being Numerous* by George Oppen," *The Mysterious Barricades*, 4, Winter 1976, pp. 97–100 and Rachel Blau DuPlessis, "Objectivist Poetics and Political Vision: A Study of Oppen and Pound," p. 128 in Burton Hatlen, ed., *George Oppen Man and Poet* (Orono, Maine: The National Poetry Foundation, 1981).

26 George Oppen, *Collected Poems*, (New York: New Directions, 1975), pp. 13 and 9.

27 Elizabeth Bishop, *The Complete Poems 1927–1979* (New York: Farrar, Straus, & Giroux, Inc., 1983), p. 127–28.

28 May Swenson, "Early Morning: Cape Cod," in *The Love Poems of May Swenson* (Boston: Houghton Mifflin Co., 1991).

29 Rozanne Knudson (biographer of May Swenson) to Gail Levin, letter of February 22, 1995. Swenson also wrote other poems that refer to this area of the Cape. In fact, it was a postcard of Hopper's *Gas* that provided inspiration for Sidney Wade's poem, "Gas," (see p. 62). Sidney Wade, in telephone conversation with Gail Levin, March 22, 1995.

From page 15

1 Edward Hopper, "John Sloan and the Philadelphians," *The Arts*, XI, April 1927, p. 178.

2 Edward Hopper, "A Statement by the Chairman of the Jury," The Catalogue of the Twenty-Second Biennial Exhibition of Contemporary Oil Paintings, (Washington, D.C.: Corcoran Gallery of Art, 1951.)

Copyrights

Contributors

DIANE BONDS' poems have appeared in the *Georgia Review, Michigan Quarterly Review, Cimarron Review, South Carolina Review, Southern Poetry Review, Poet Lore*, and other journals. Author of essays on contemporary writers and a book on D.H. Lawrence, she lives and works in New York City.

MARIANNE BORUCH, who teaches in the graduate creative writing program at Purdue University, has published three collections of poetry, *Moss Burning, Descendant,* and *View from the Gazebo.* She is also author of a collection of essays, *Poetry's Old Air.*

WILLIAM CARPENTER is author of three books of poetry, including *Speaking Fire at Stones,* and a recent novel, *A Keeper of Sheep* (Milkweed Editions). He teaches at the College of the Atlantic in Maine.

ANNE BABSON CARTER, whose poems appear in *The Nation, The Paris Review, Western Humanities Review,* and elsewhere, is at work on her first collection of poetry. She grew up in Gloucester, Massachusetts where Hopper painted.

SIMON CUTTS is an English poet, publisher, and object maker who in 1975 began Coracle Press, which has also spawned galleries and bookshops.

STEPHEN DUNN is the author of nine collections of poetry, including *New & Selected Poems, 1974–1994* published by W.W. Norton and Co.

W.R. ELTON is Professor in the Ph.D. Program in English at The Graduate School of The City University of New York. He has published his poems widely. His most recent collection is *Wittgenstein's Trousers* (New York: Mellen, 1991).

DEBORA GREGER teaches in the creative writing program of the University of Florida in Gainesville. Her fourth book of poems, *Off-Season at the Edge of the World,* was published in 1994 by the University of Illinois Press.

EDWARD HIRSCH, who teaches at the University of Houston, has published four books of poetry including *For the Sleepwalkers, Wild Gratitude, The Night Parade, Earthly Measures* (all Alfred A. Knopf).

JOHN HOLLANDER, who is A. Bartlett Giamatti Professor of English at Yale University, was made a Fellow of the MacArthur Foundation in 1990. His is author of several books of criticism and many books of poems, including *Selected Poetry* (Alfred A. Knopf, 1993).

LARRY LEVIS teaches at Virginia Commonwealth University in Richmond, Virginia, and is currently completing a sixth book of poems. He also writes short stories.

SUSAN LUDVIGSON's most recent collections of poems are *To Find the Gold* and *Everything Winged Must Be Dreaming,* both from LSU Press. She is a recipient of Guggenheim, Rockefeller, Fulbright, NEA and other fellowships, and teaches at Winthrop University in Rock Hill, South Carolina.

ROBERT MEZEY's *Evening Wind* was published by Wesleyan University Press is 1987 and is being re-issued by Carnegie-Mellon in the fall of 1995. With Richard Barnes, he translated *The Collected Poems of Jorge Luis Borges,* which will be published by Viking Penguin in 1996.

LISEL MUELLER is the author of five collections of poetry, including *The Need to Hold Still,* which won the 1981 National Book Award. Her latest collection is *Waving from Shore.*

JOYCE CAROL OATES is the author of a number of works of fiction, poetry, and criticism, and is on the faculty at Princeton University.

TONY QUAGLIANO has various works in *The Encyclopedia of Psychology*, JAMA, *Harvard Review, Rolling Stone, New York Quarterly, Exquisite Corpse, Yankee, New Directions*, and *The Pushcart Prize: Best of the Small Presses*. He is editor of KAIMANA (Diamond), the journal of the Hawaii Literary Arts Council.

LAWRENCE RAAB is the author of four collections of poetry. The most recent, *What We Don't Know About Each Other* (Penguin, 1993) was a winner for the National Book Award. He teaches at Williams College in Massachusetts.

DAVID RAY has published several books of poetry including *The Tramp's Cup, Sam's Book, The Maharani's New Wall, Wool Highways and Other Poems*, and most recently *Kangaroo Paws*. He is now at work on *The Endless Search*, a memoir.

ANTHONY RUDOLF is an English poet whose books include *The Manifold Circle, The Same River Twice*, and *After the Dream*. He is also a translator of French and Russian poetry.

IRA SADOFF is author of four collections of poetry, most recently *Emotional Traffic* and *An Ira Sadoff Reader*, a collection of stories, poems, and essays.

GRACE SCHULMAN's latest poetry collection is *For That Day Only* (Sheep Meadow Press). She is Poetry Editor of *The Nation* and Professor of English at Baruch College of The City University of New York.

SUE STANDING is the author of three collections of poems, *Amphibious Weather, Deception Pass*, and *Gravida*. The recipient of grants from the National Endowment for the Arts and the Bunting Institute, she directs the Creative Writing Program at Wheaton College in Massachusetts.

JOHN STONE is a cardiologist at Emory University School of Medicine. His books (*The Smell of Matches, In All this Rain*, and *Renaming the Streets*) are all from LSU Press. A book of his essays, *In The Country of Hearts*, was published in 1990. He is now at work on a volume of new and selected poems.

JOHN UPDIKE is author of novels, short stories, essays, and poetry. His *Collected Poems 1953–1993* was published by Alfred A. Knopf.

SIDNEY WADE's book of poems, *Empty Sleeves*, was published in 1991 by the University of Georgia press. She is currently at work on a series of poems based in Istanbul, where she lived and worked as a Fulbright professor in 1989–90. She teaches in the creative writing program at the University of Florida in Gainesville.

ALAN WILLIAMSON is the author of *Presence, The Muse of Distance*, and three books of literary criticism. His latest book of poems, *Love and the Soul*, is published in the University of Chicago Press Phoenix Poets series. He teaches at the University of California at Davis.

SAMUEL YELLEN, who taught at Indiana University, wrote poetry and fiction. His poem after Edward Hopper, initially published in 1951, is the earliest such example to come to light. His last book, *Nighthawks: Poems Dark and Light* was published posthumously in 1983.

Illustrations